T0118477

Web's Crazy 8 Tattoo Coloring Book

Cool Tattoo Coloring Book

Renee' Alina Barela Pontious

Order this book online at www.trafford.com
or email orders@trafford.com

Most Trafford titles are also available at major online book retailers.

Printed in the United States of America.

ISBN: 978-1-4669-0748-5 (sc)
ISBN: 978-1-4669-0749-2 (e)

Trafford rev. 04/14/2012

North America & international
toll-free: 1 888 232 4444 (USA & Canada)
phone: 250 383 6864 ♦ fax: 812 355 4082

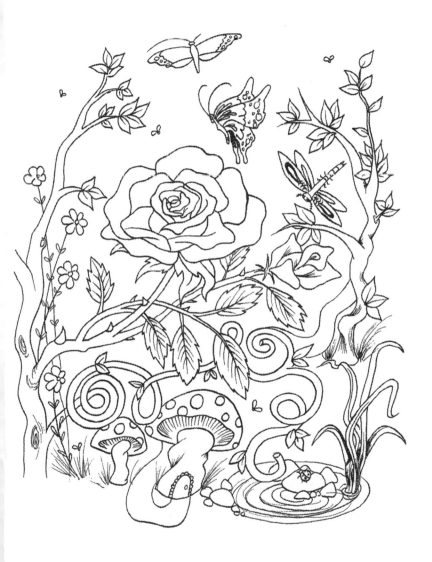

Web`s Crazy 8 Tattoo Designs By Renee` Alina Barela

1

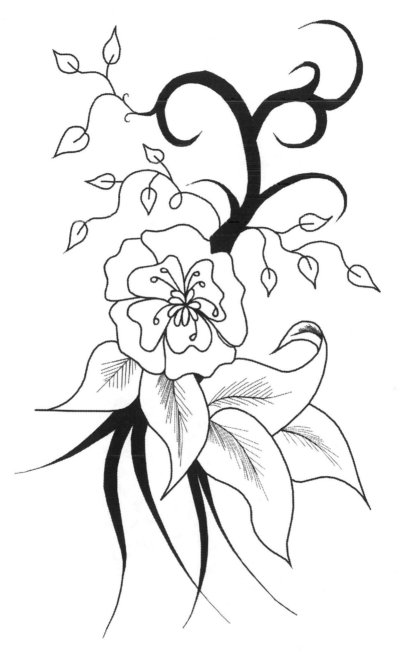

Web's Crazy 8 Tattoo Designs By Renee' Alina Barela

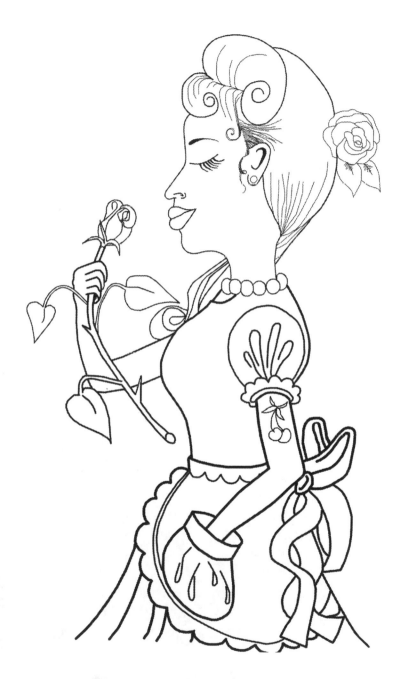

Web`s Crazy 8 Tattoo Designs By Renee` Alina Barela

5

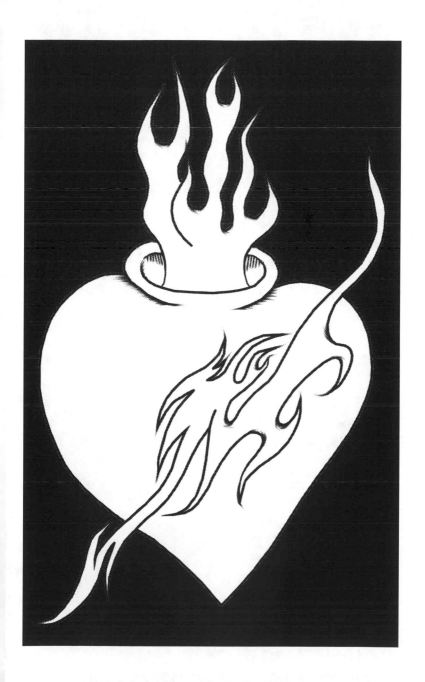

Web's Crazy 8 Tattoo Designs By Renee` Alina Barela

7

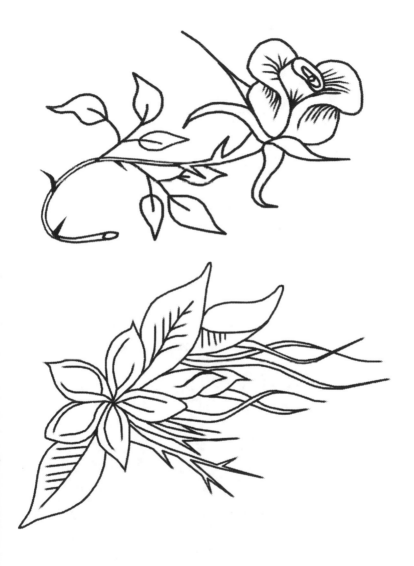

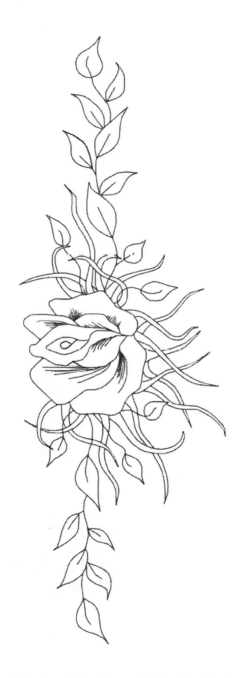

Web`s Crazy 8 Tattoo Designs By Renee` Alina Barela

11

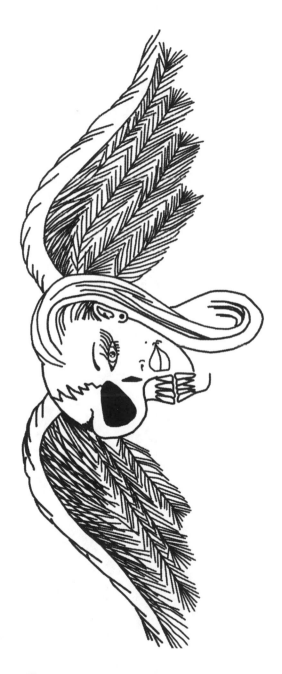

Web`s Crazy 8 Tattoo Designs By Renee` Alina Barela

13

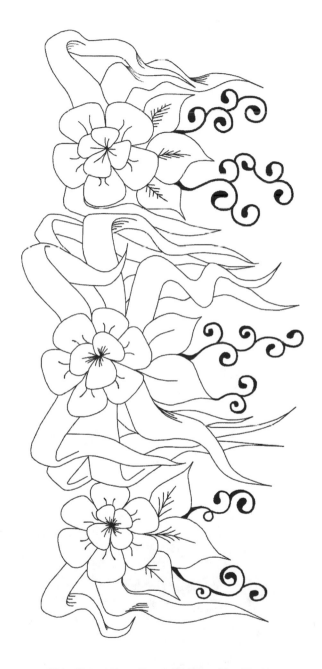

Web`s Crazy 8 Tattoo Designs By Renee` Alina Barela

15

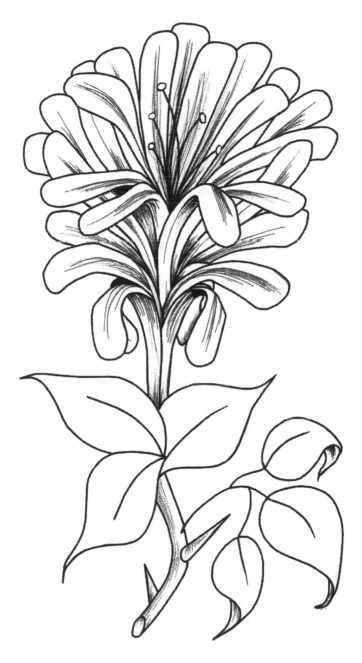

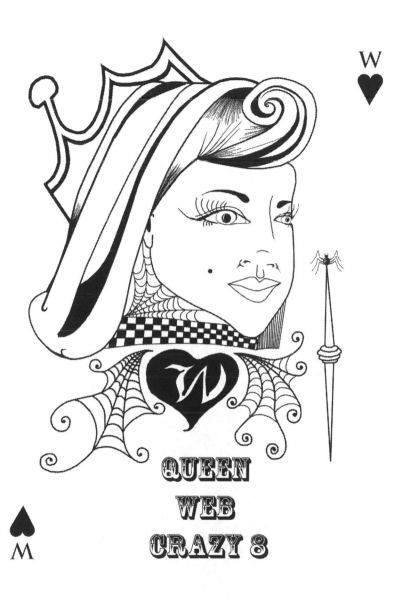

QUEEN
WEB
CRAZY 8

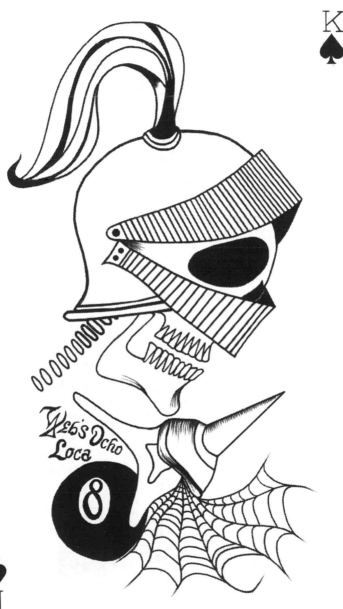

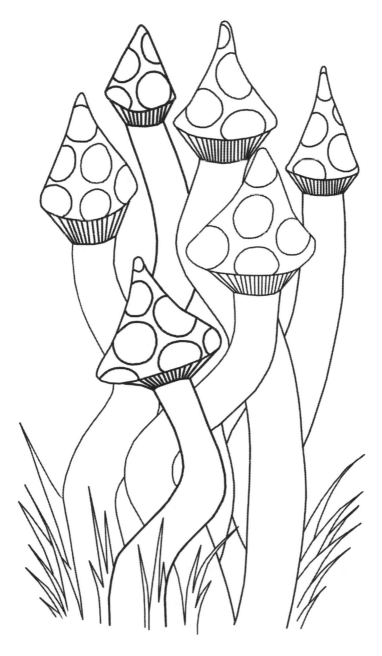

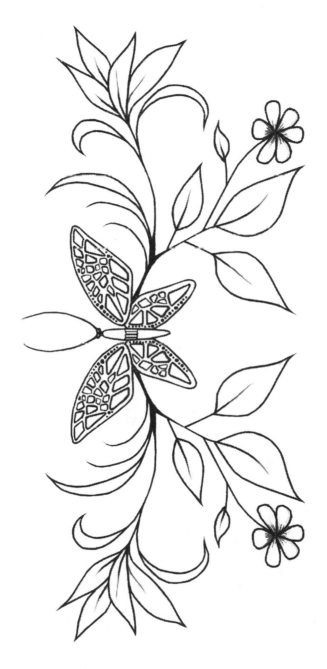

Web's Crazy 8 Tattoo Designs By Renee` Alina Barela

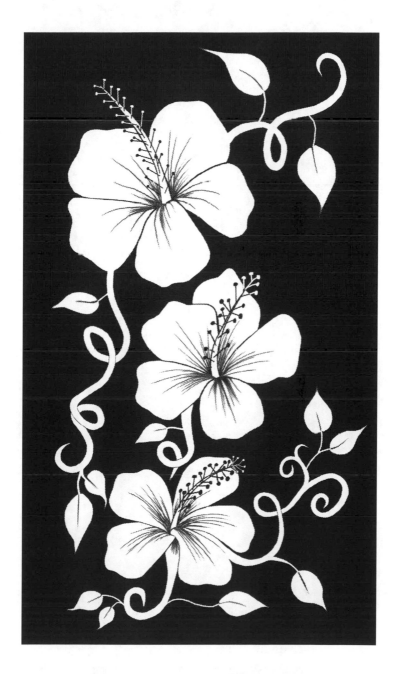

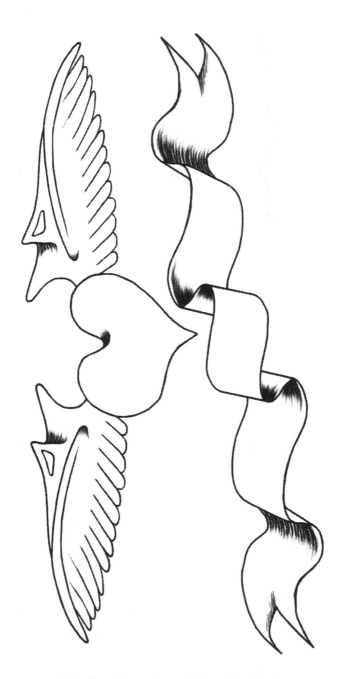

Web's Crazy 8 Tattoo Designs By Renee` Alina Barela

33

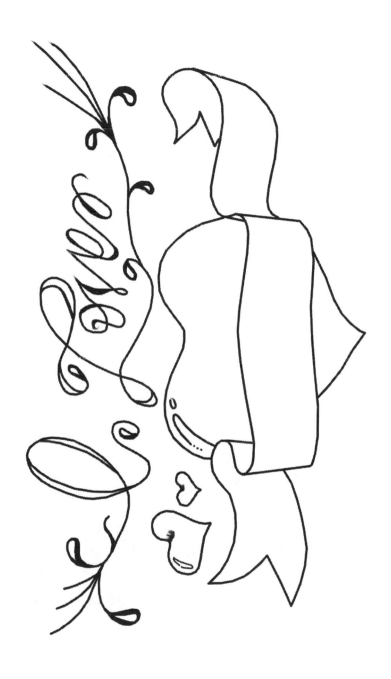

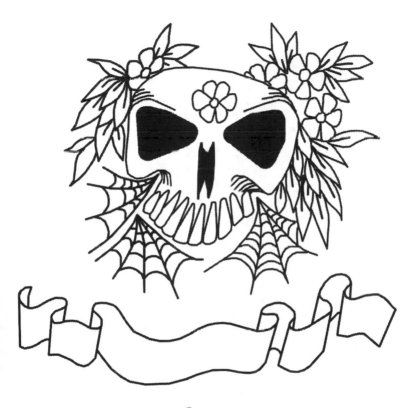

Web's Crazy 8 design

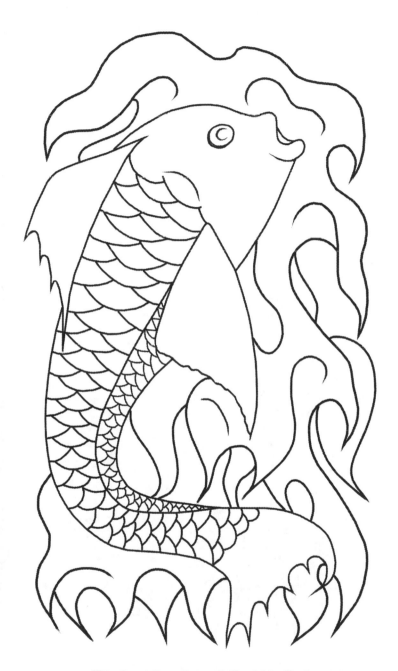

Web`s Crazy 8 Tattoo Designs By Renee` Alina Barela

39

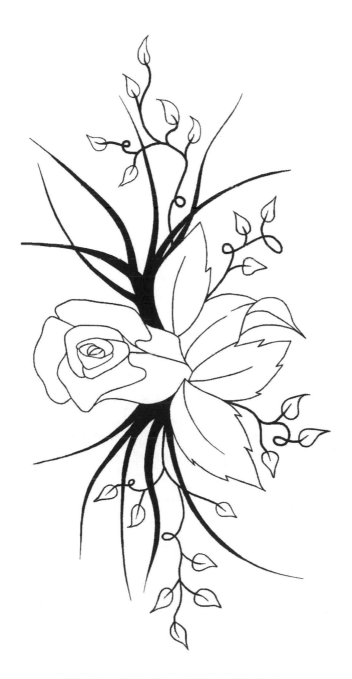

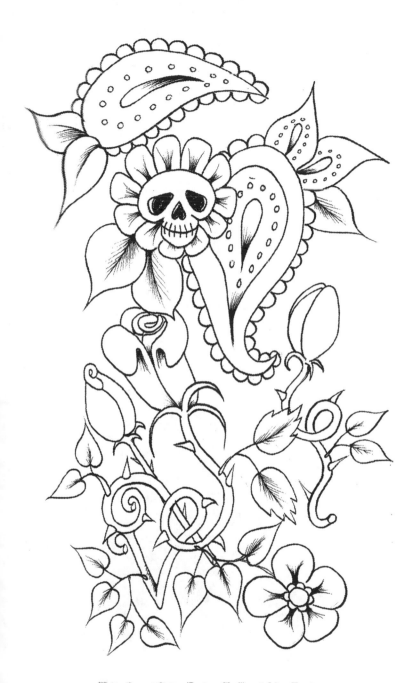

Web`s Crazy 8 Tattoo Designs By Renee` Alina Barela

43

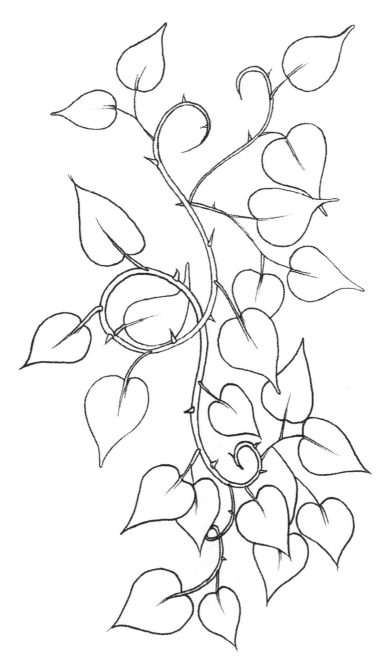

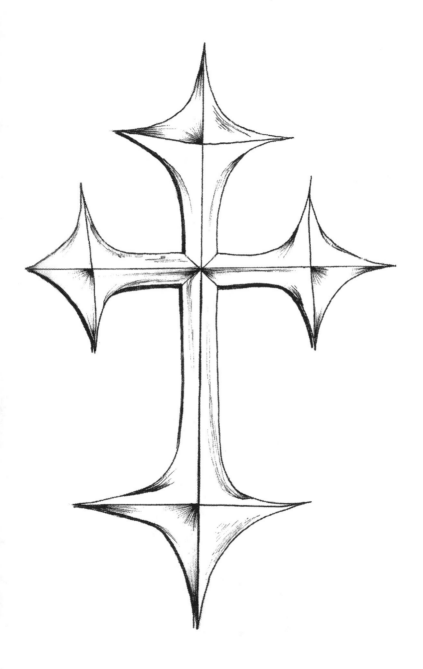

Web's Crazy 8 Tattoo Designs By Renee` Alina Barela

47

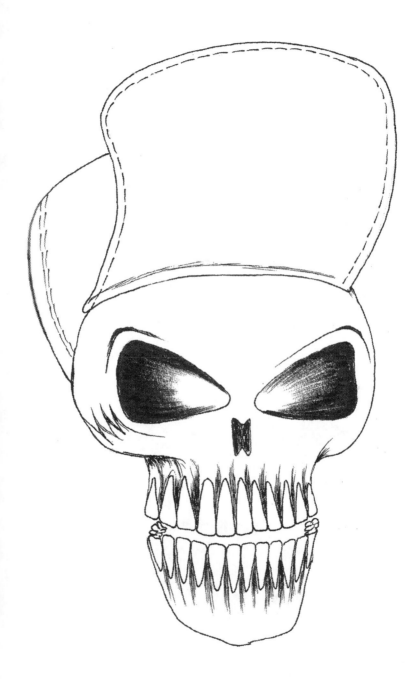

Web's Crazy 8 Tattoo Designs By Renee` Alina Barela

49

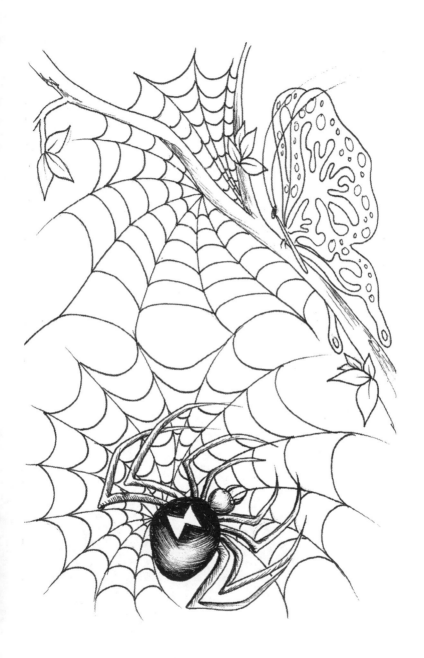

Web`s Crazy 8 Tattoo Designs By Renee` Alina Barela

51

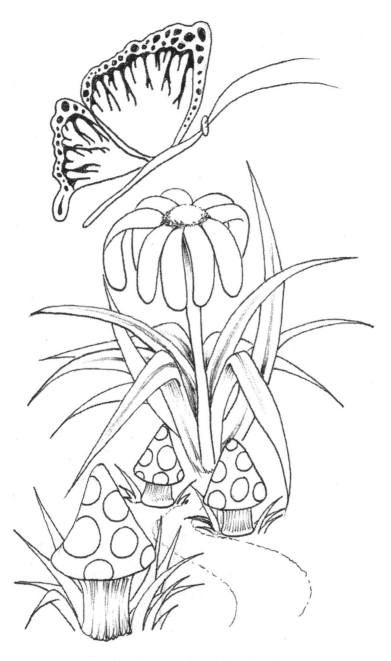

Web`s Crazy 8 Tattoo Designs By Renee` Alina Barela

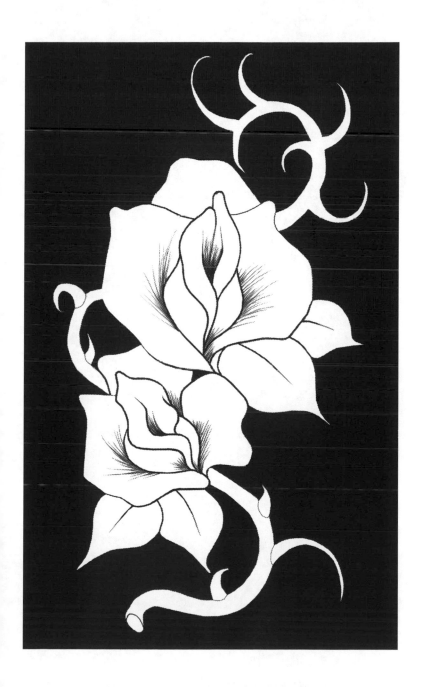

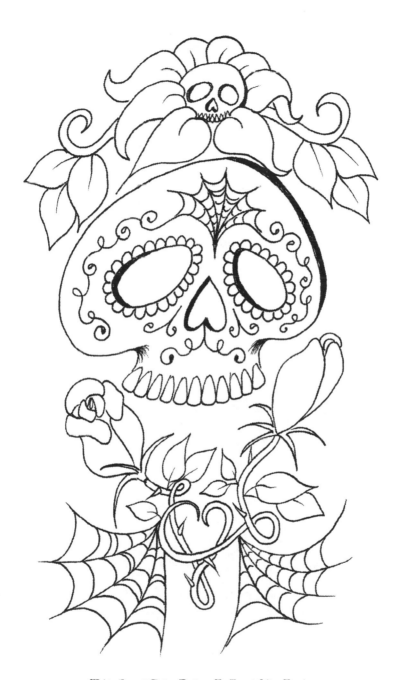

Web`s Crazy 8 Tattoo Designs By Renee` Alina Barela

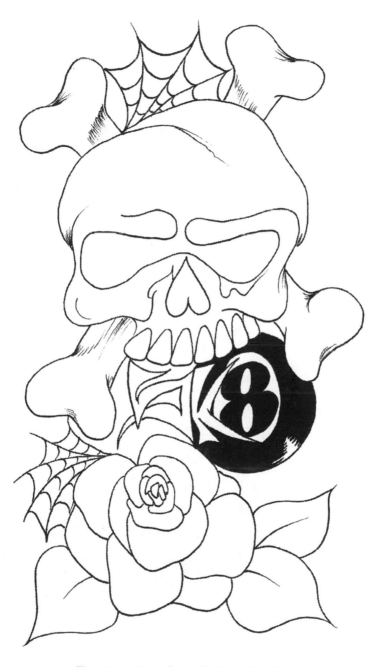

Web's Crazy 8 Tattoo Designs By Renee` Alina Barela

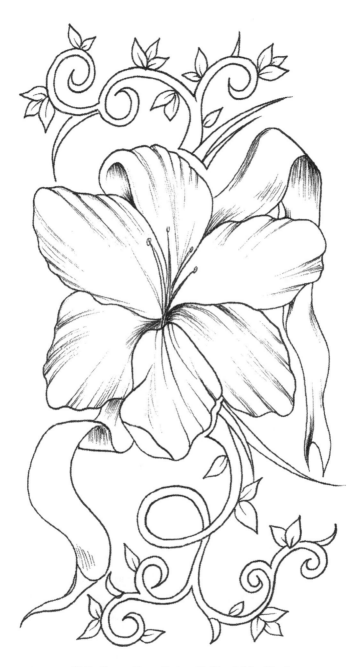

Web's Crazy 8 Tattoo Designs By Renee` Alina Barela

Author Biography

The author's name is Renee Alina Barela Pontious. She grew up in Lakewood, California, and has always loved to draw since she was in second grade. She also likes to paint, sell her drawings, and do many crafts besides tattooing. She is also a musician. She plays guitar and violin. She loves to draw and use colors to bring out the life in her pictures. I hope you enjoy coloring her book and are inspired to accept people that are different.

She also likes to dress different and have differently colored hair like red, purple, and blue.

Book Summary

You can be an individual and have your own opinion on the way you like to dress or are like. If someone is different from you, accept them for who they are because it always comes back around to you. If someone is different, such as their race or handicap, maybe they have birth defects or have different parents than everyone else, or maybe they have tattoos and piercings. If they are different, it can be an interesting experience to get to know them. There are many different people in the world. If you are different and someone doesn't like you, don't worry and never let anyone

bully you. Have confidence in yourself, that you are special, and don't let anyone make you feel bad. Being an individual means that you are different in a good way, and other people will appreciate you. Don't follow what other people like all the time. Have your own opinion, and maybe people will follow what you like. If not, it's good to be different, and it's fun to be creative. The world is your palette. You don't need Halloween to express yourself. You can express yourself any day of the year!

Key words

tattoo, coloring book, cool designs, web's crazy 8, webs ocho loca, flash art